Thank you for choosing "The Book of Del by Pretty Pine Press!

C000134017

Would you like a **FREE e-BOOK?**

PICTURE BOOK OF
BEAUTIFUL BIRDS

To claim your gift email us at
prettypinepress@gmail.com

WE'D LOVE YOUR FEEDBACK!

Please let us know how we are doing
by leaving us a review on Amazon.

PRETTY PINE
PRESS

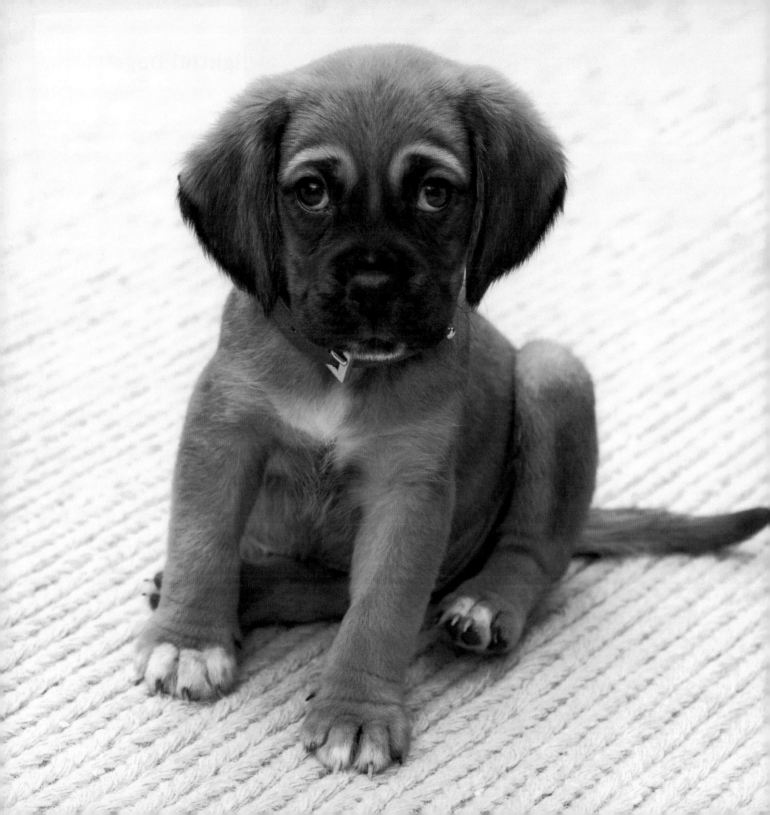

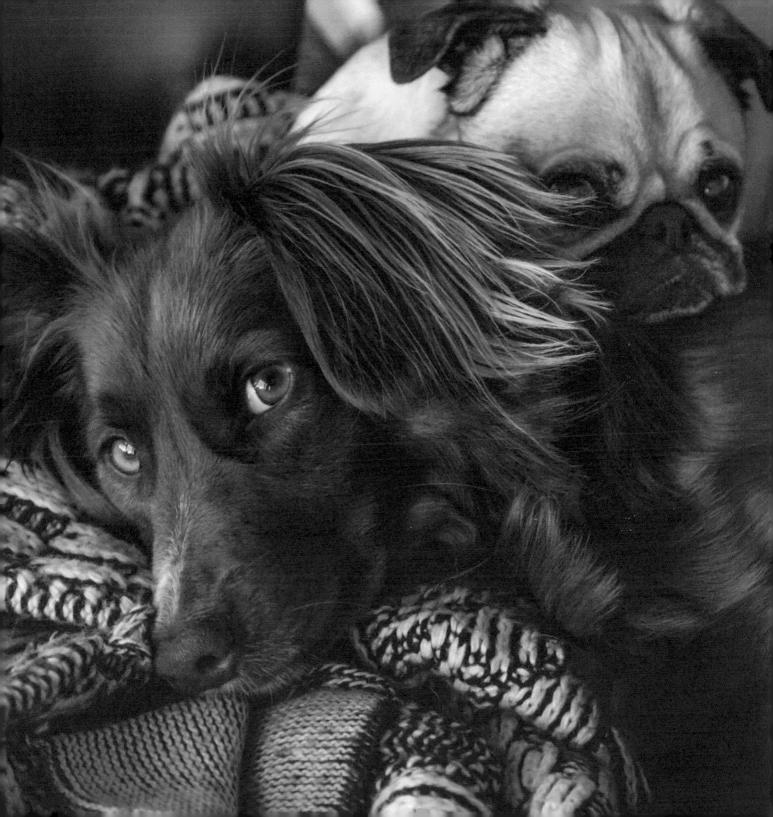

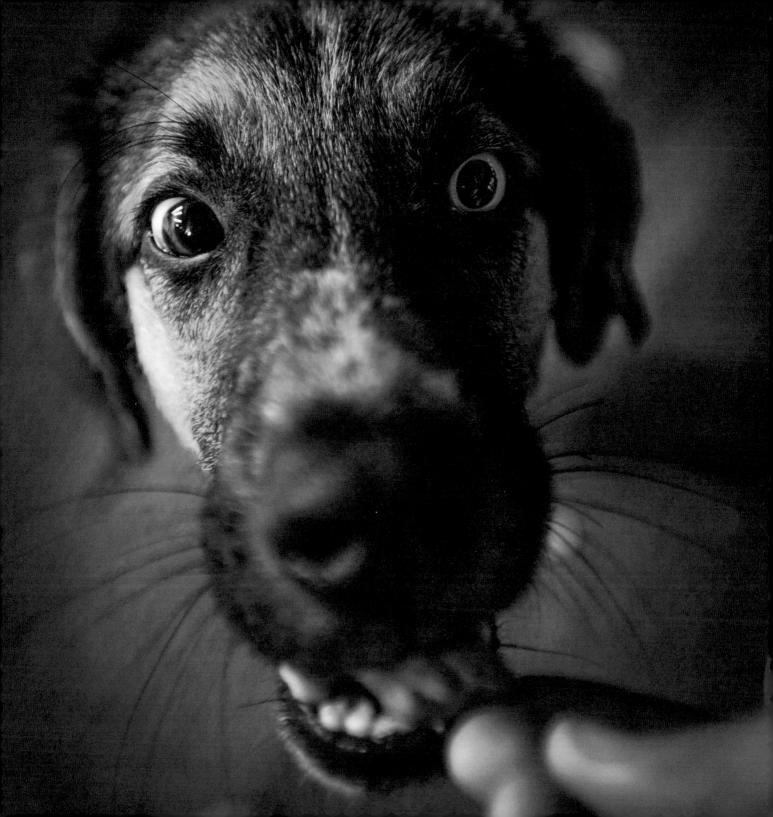

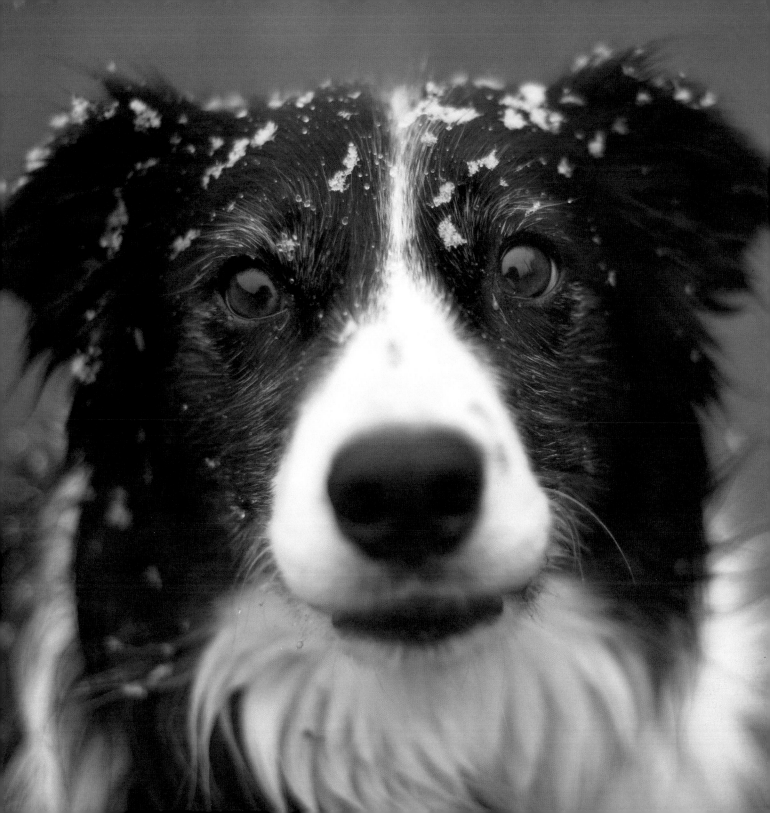

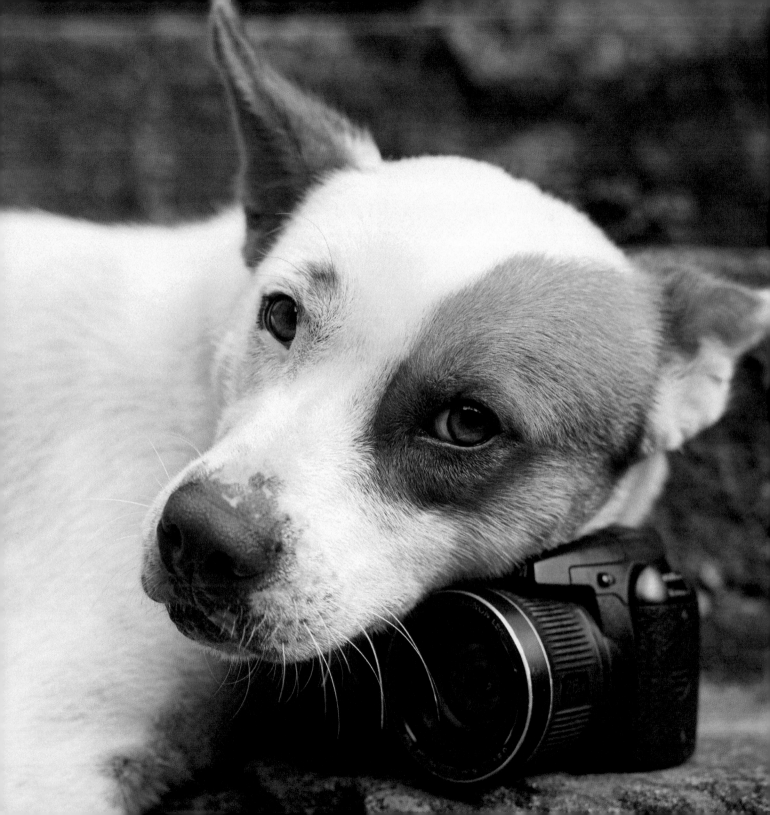

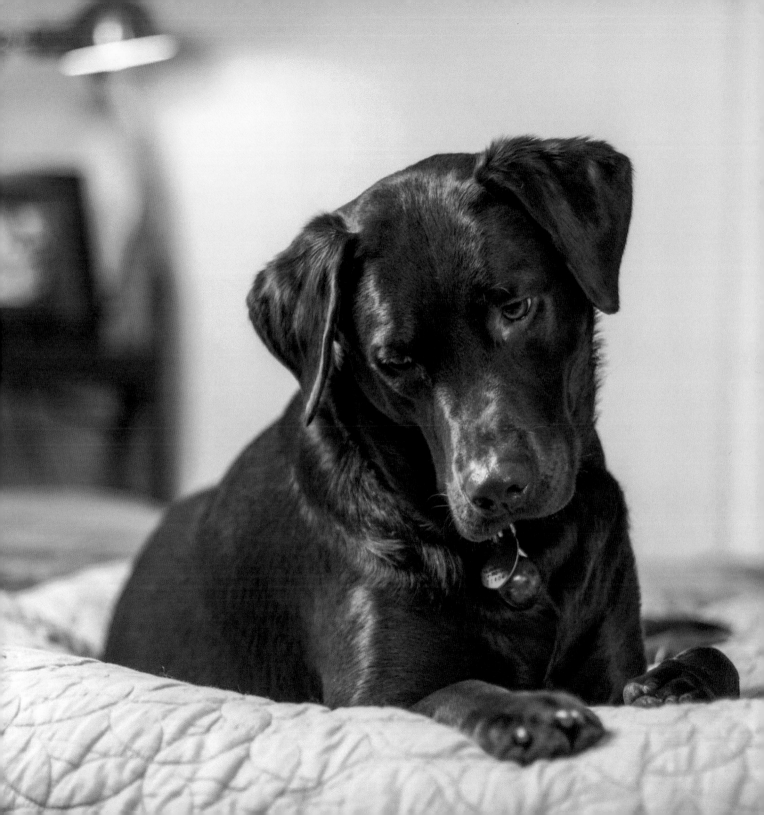

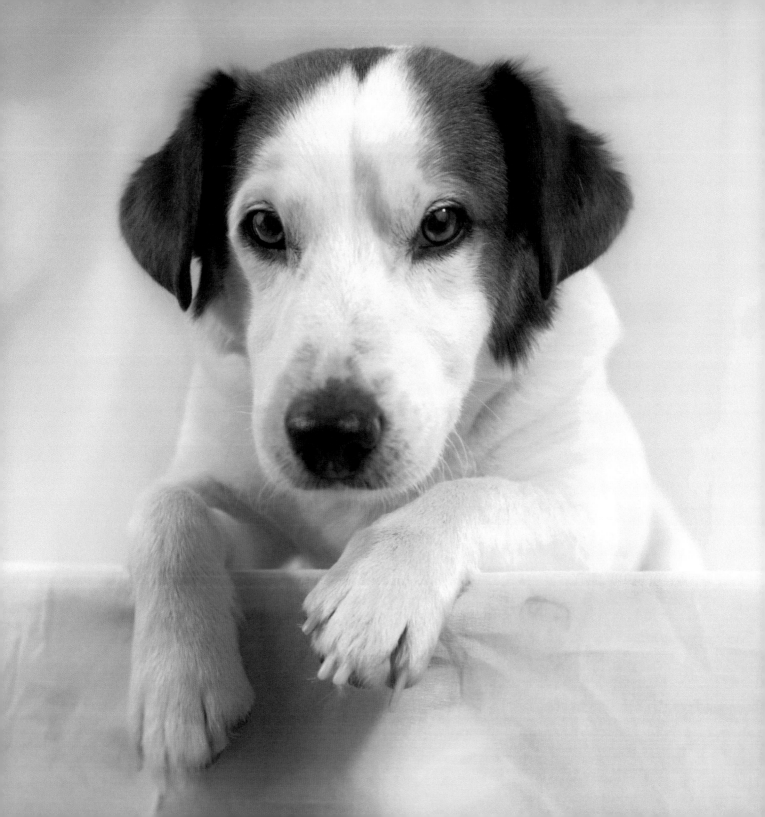

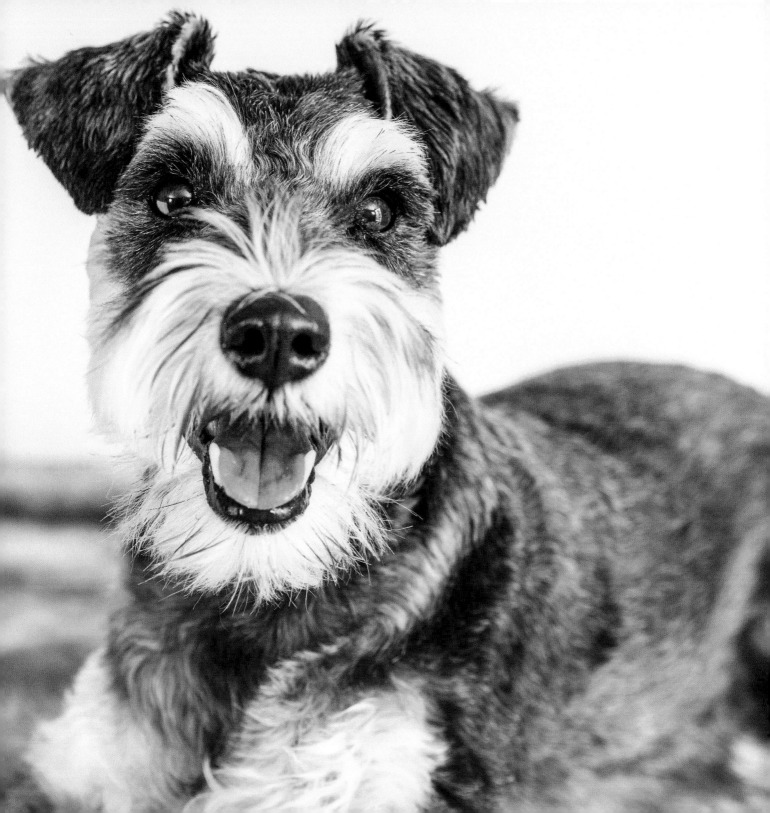

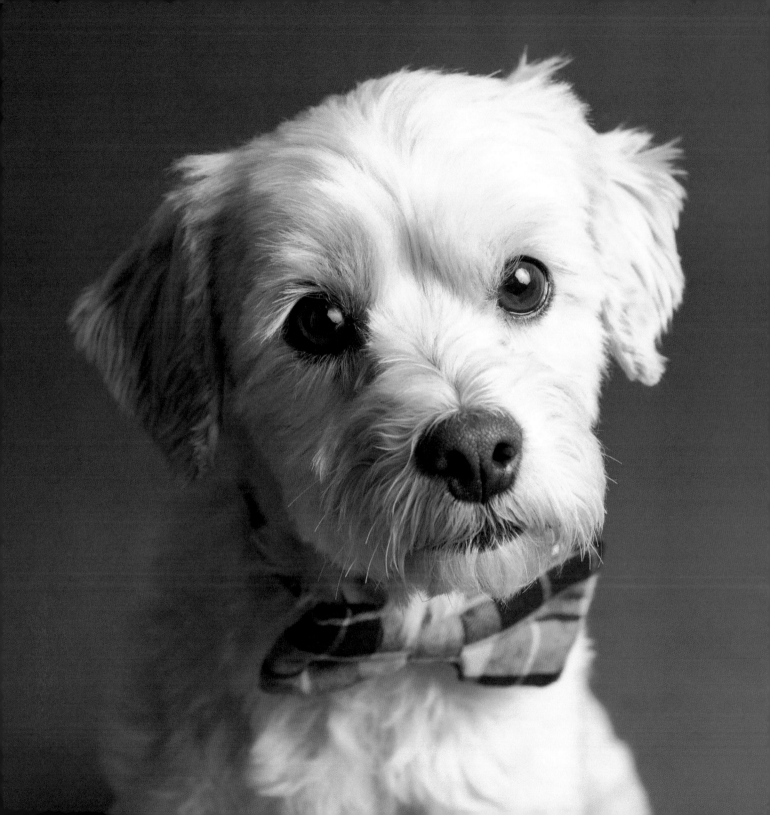

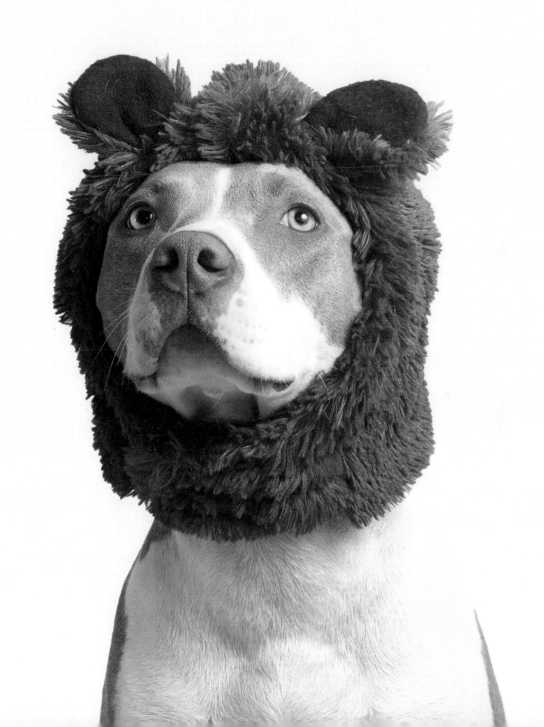

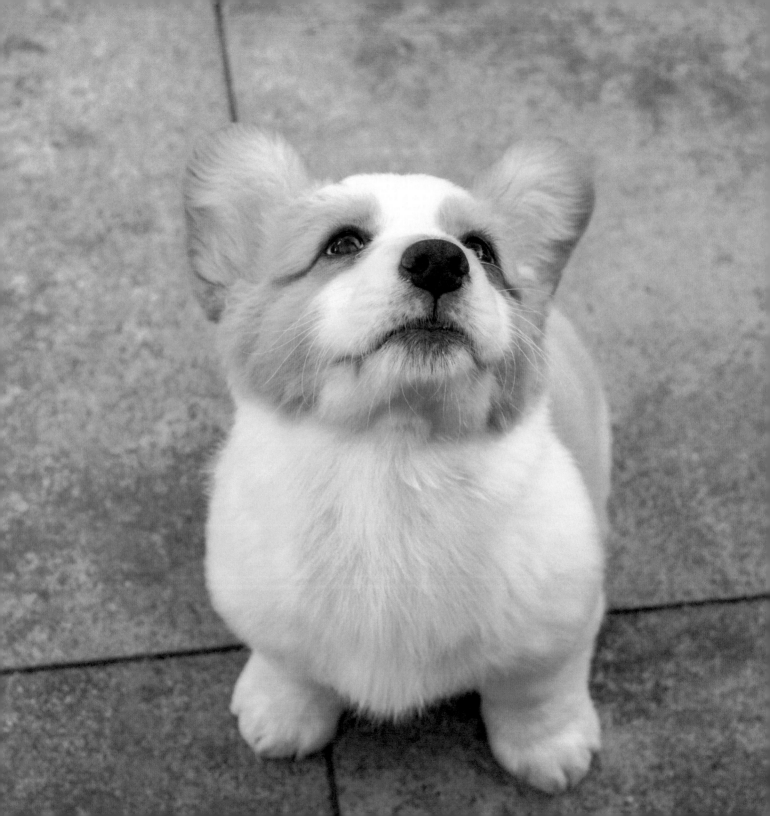

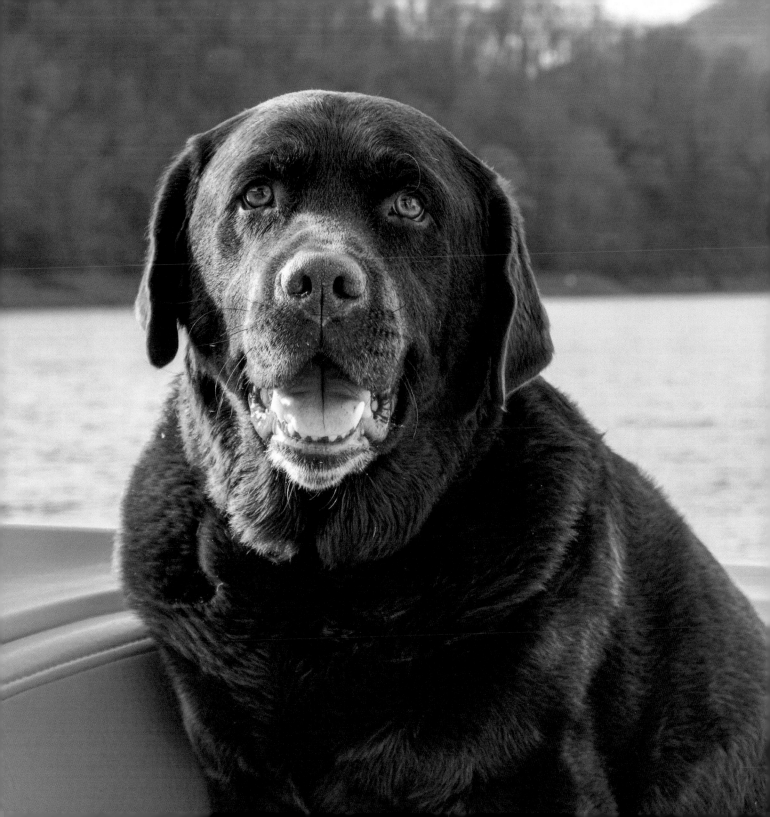

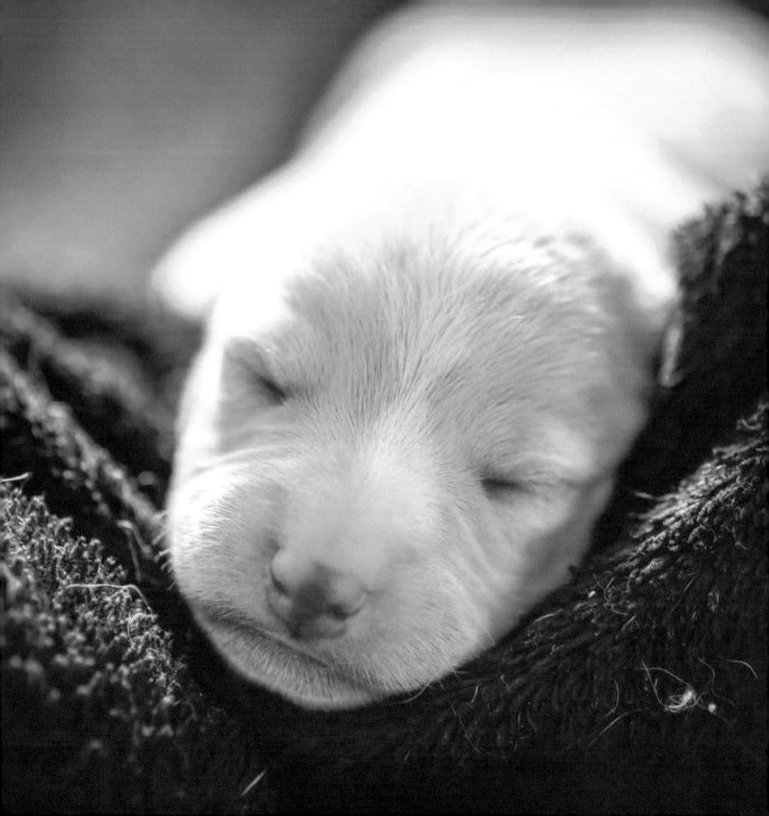

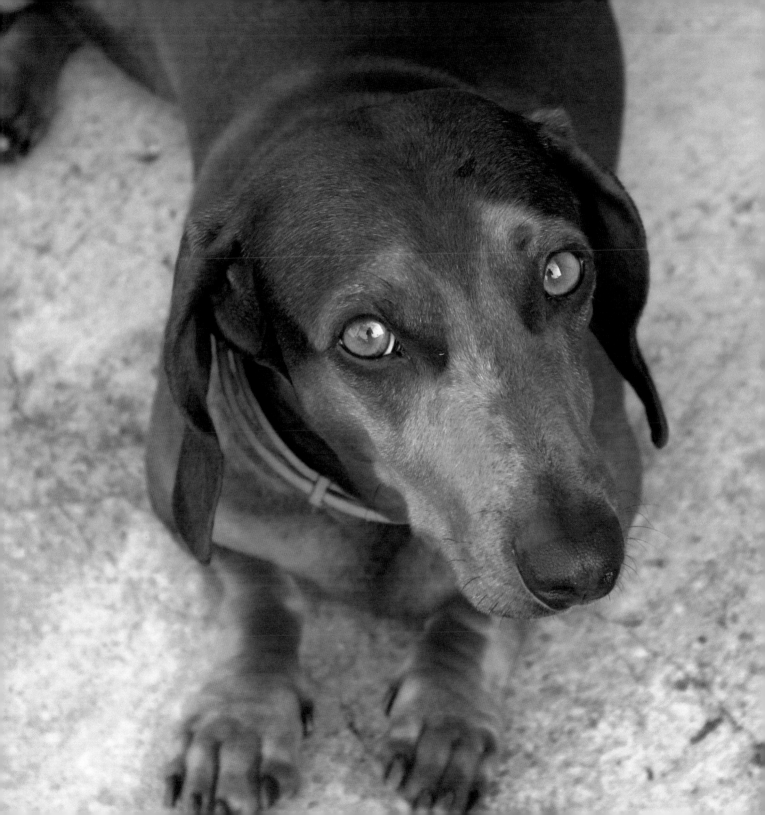

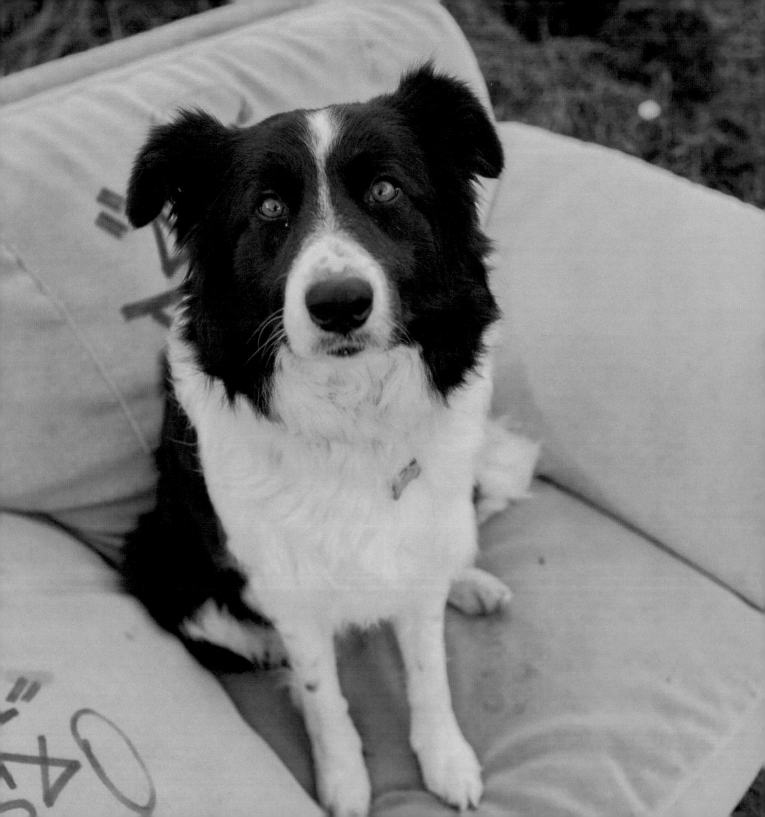

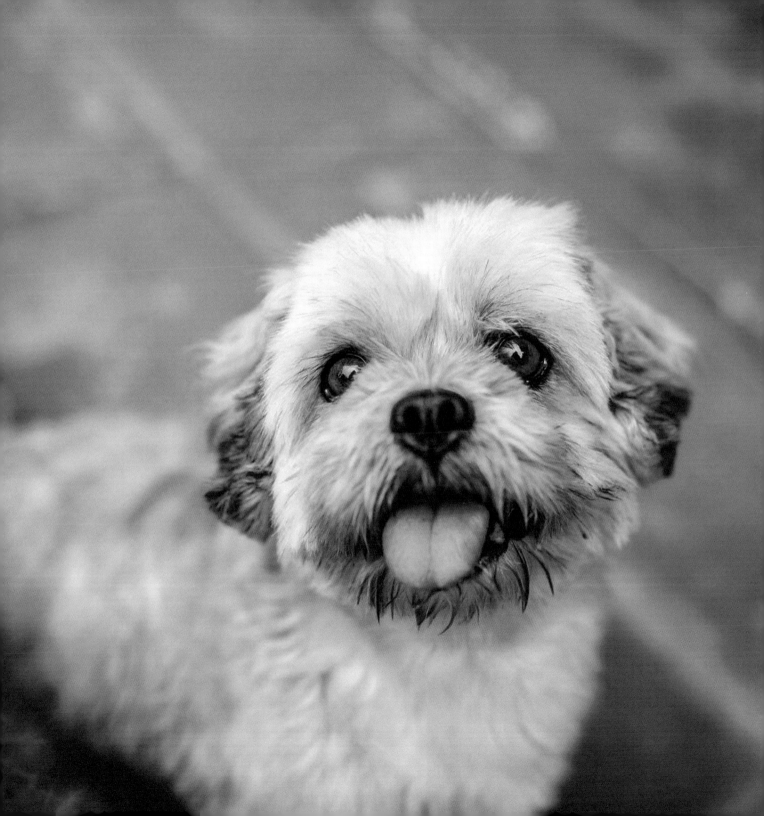

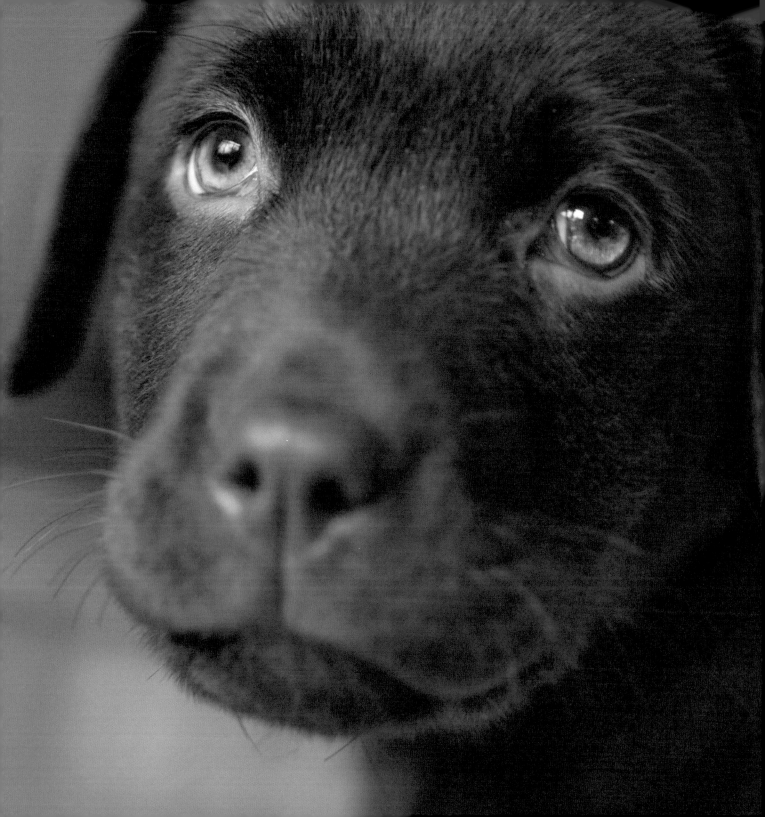

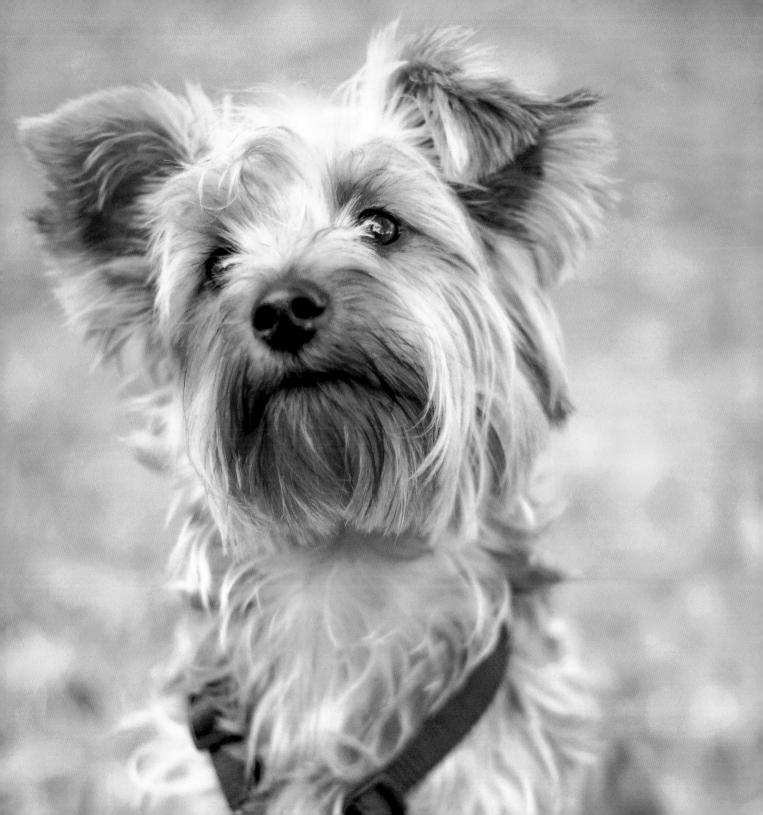

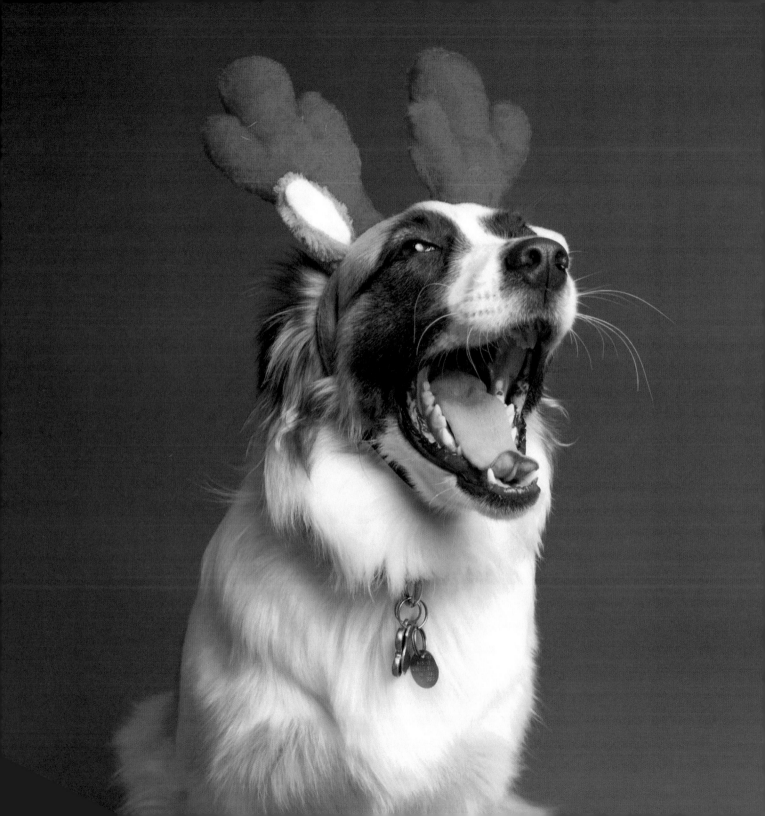

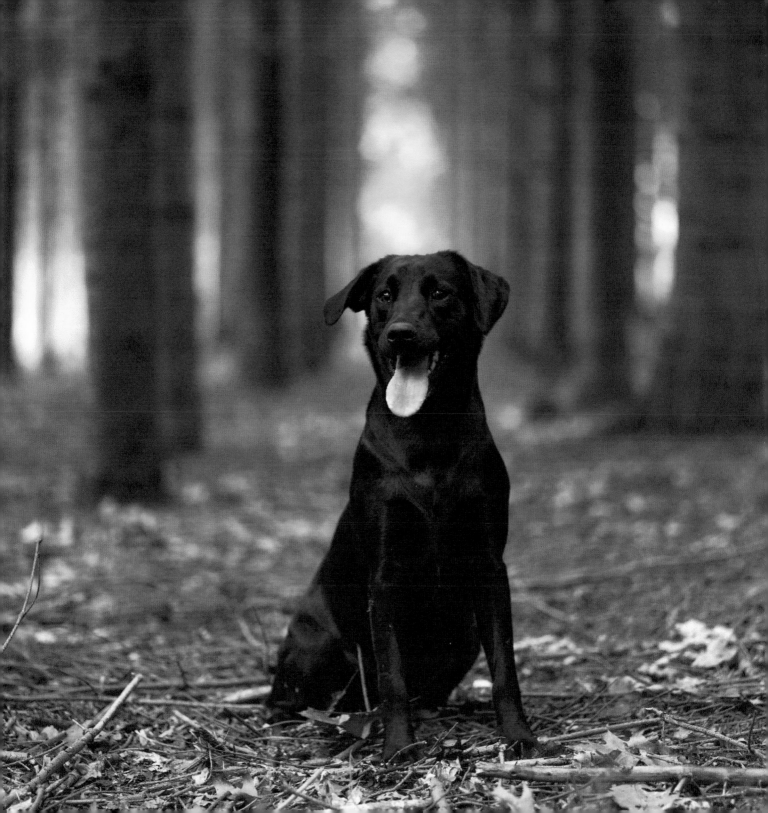

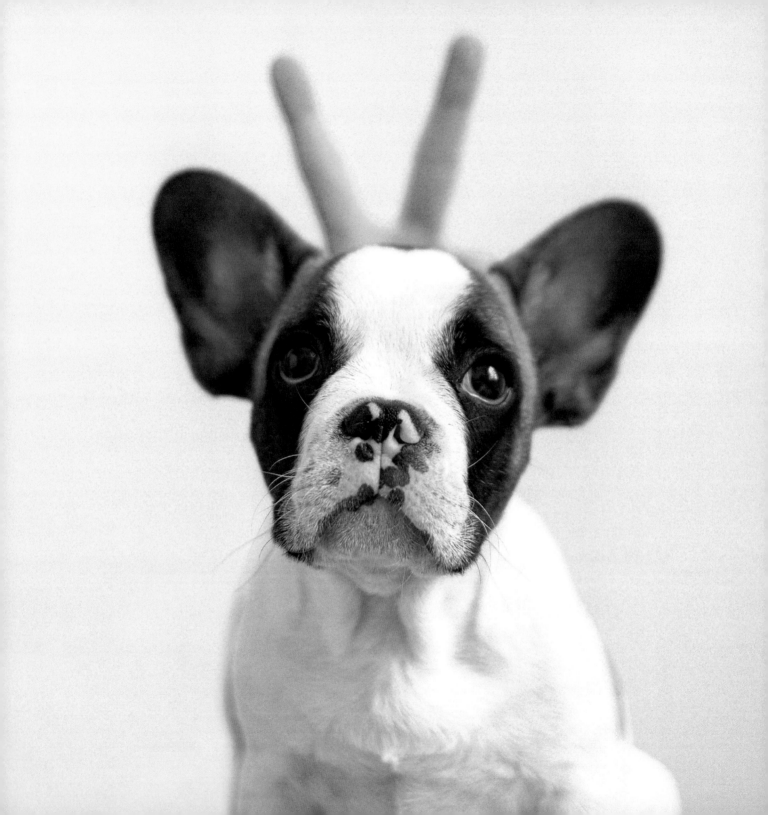

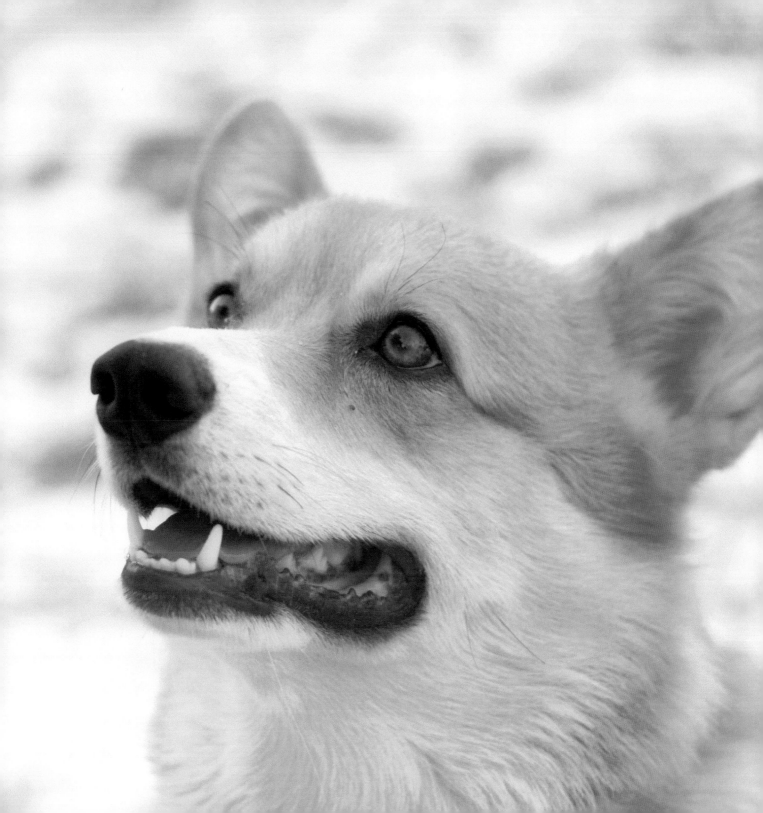

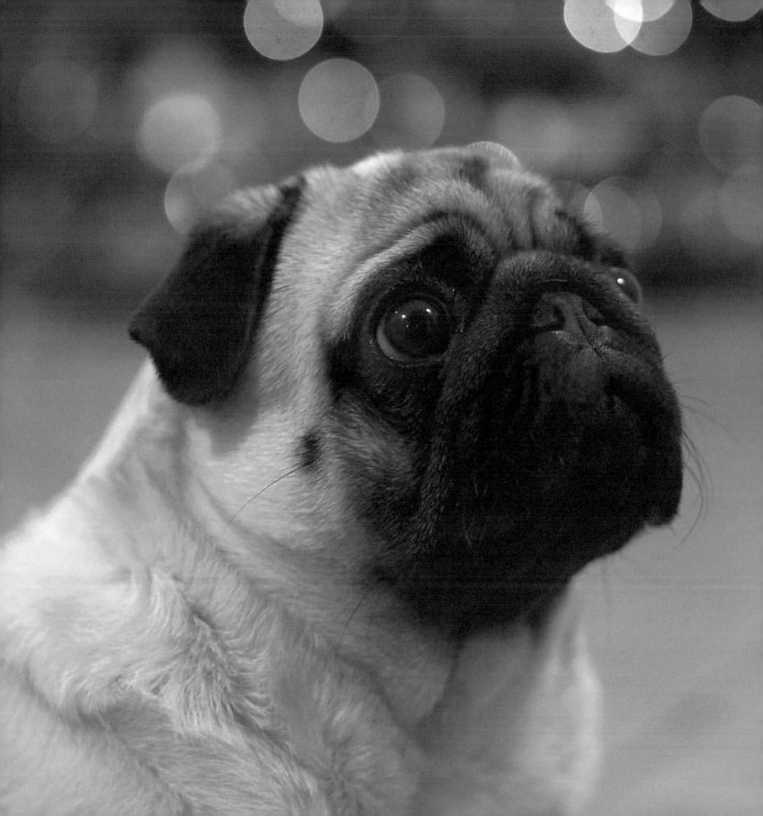

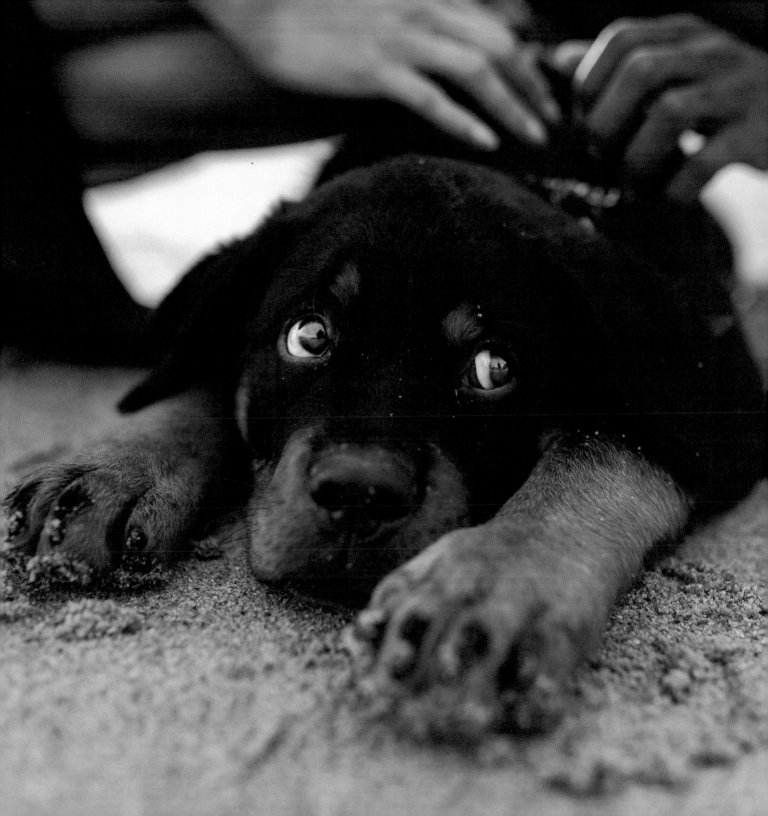

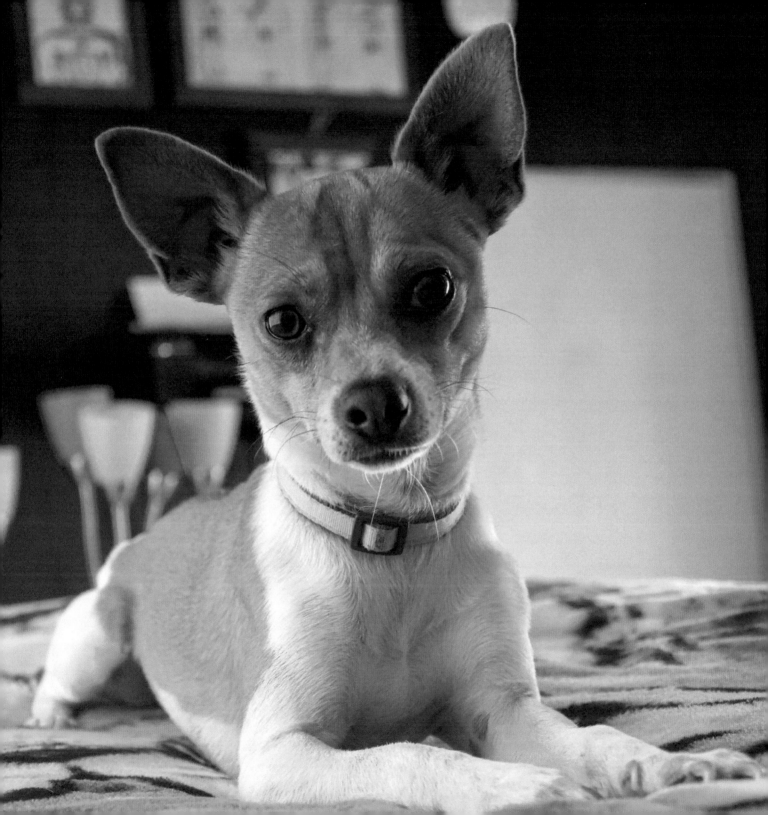

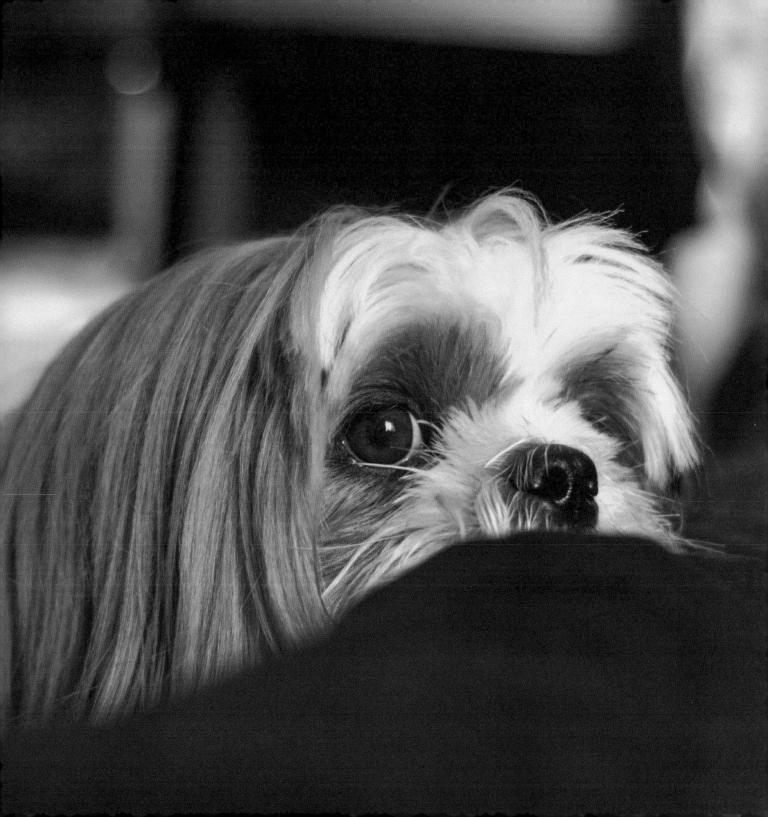

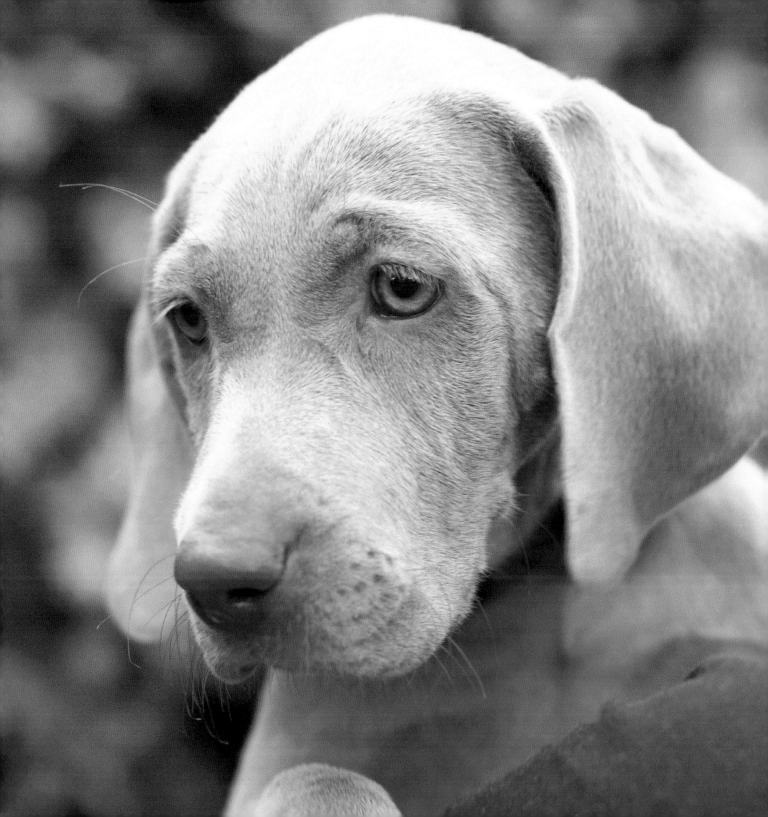

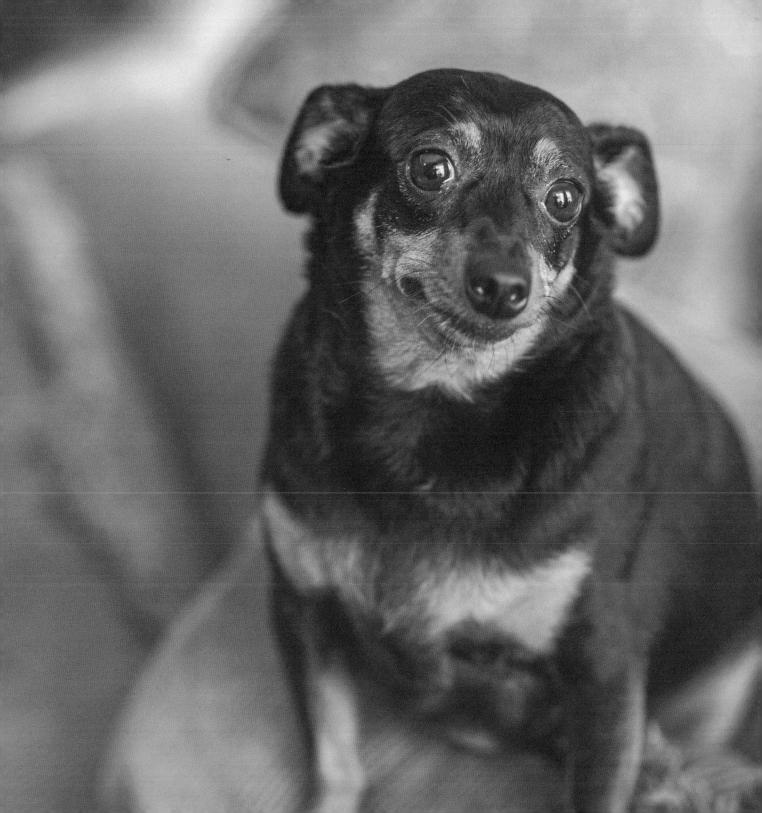

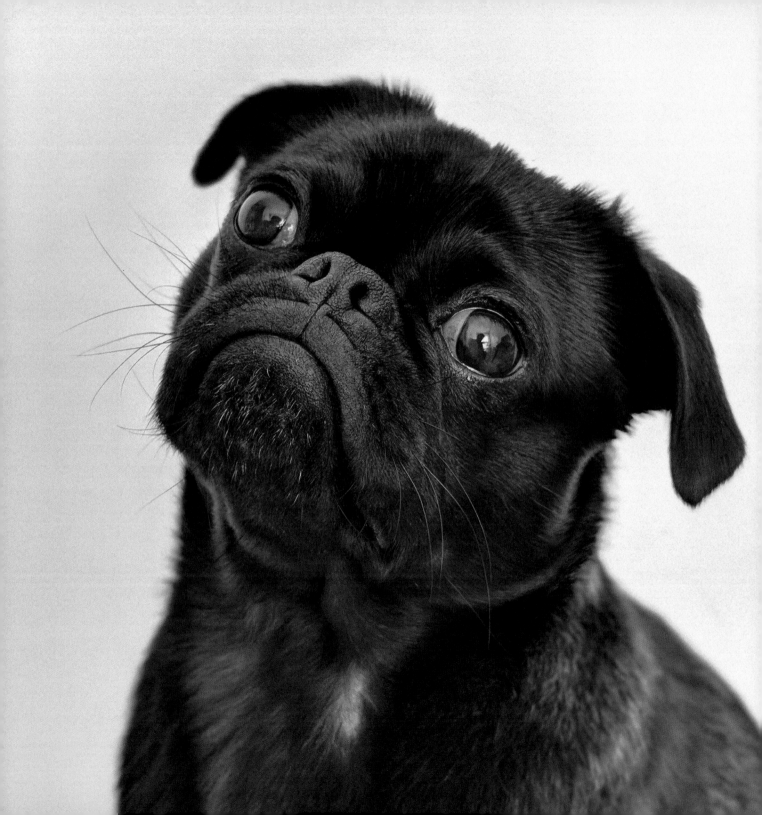

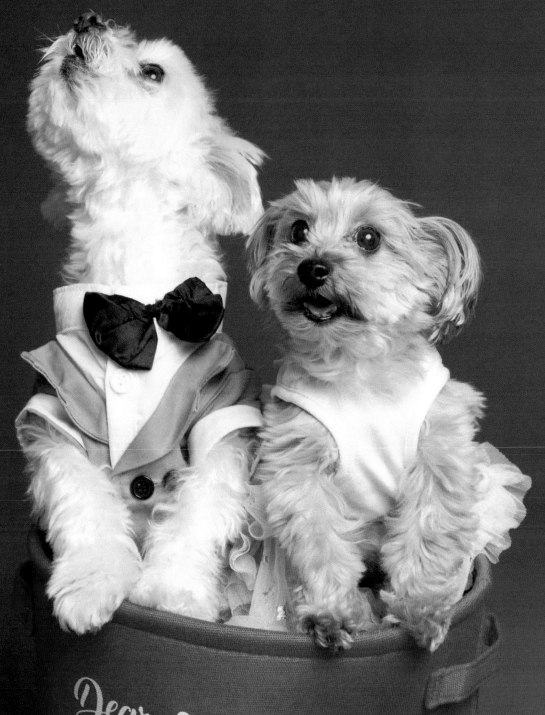

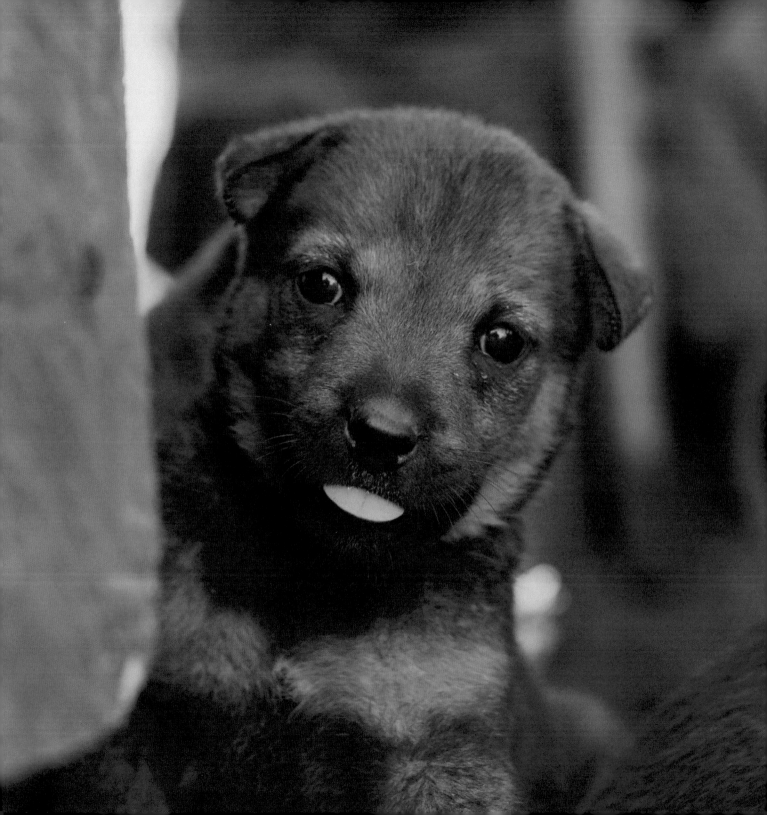

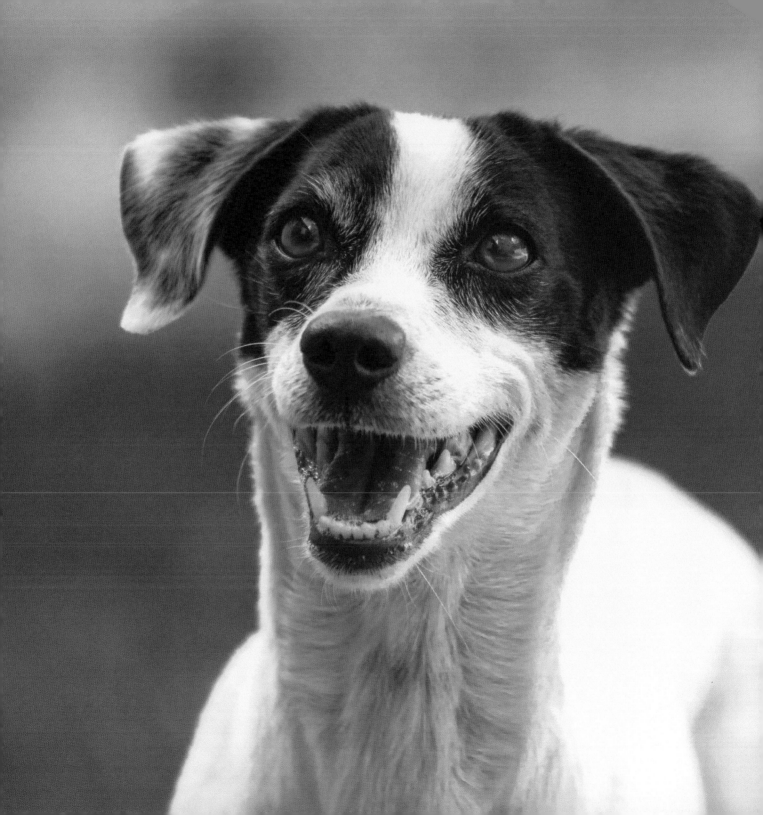

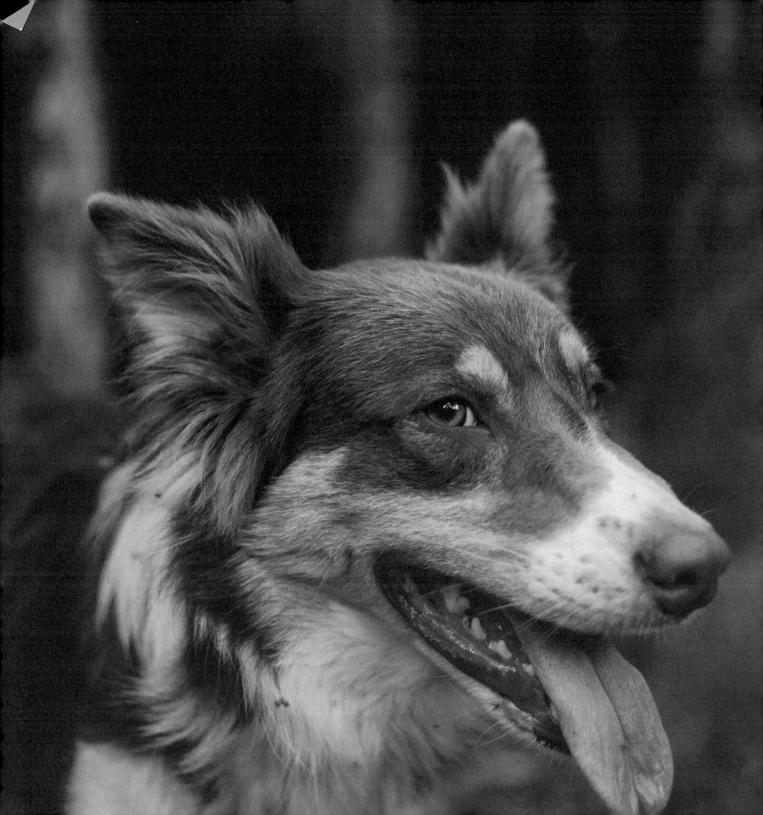

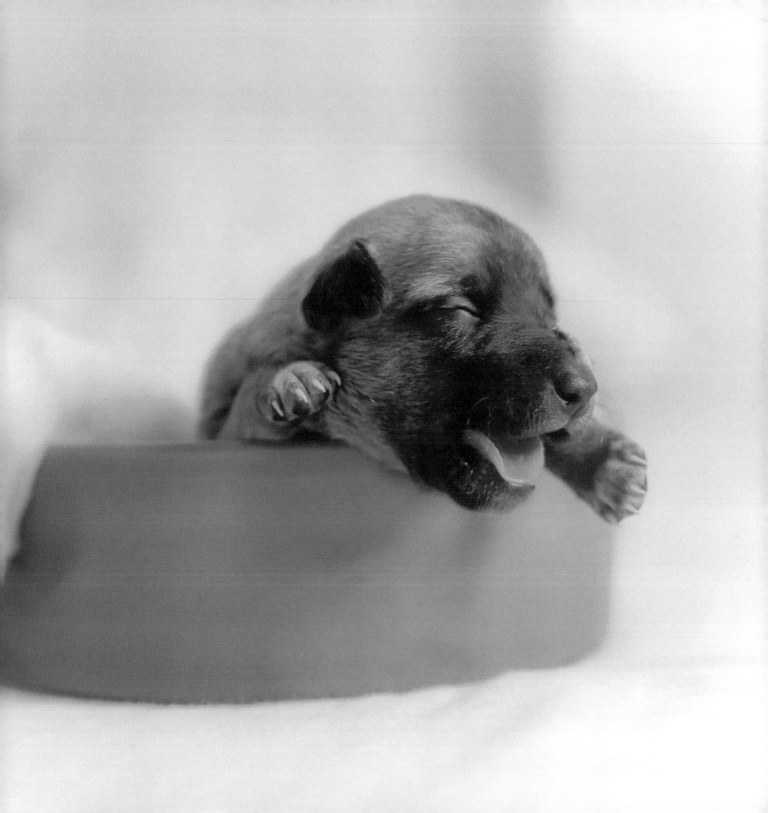

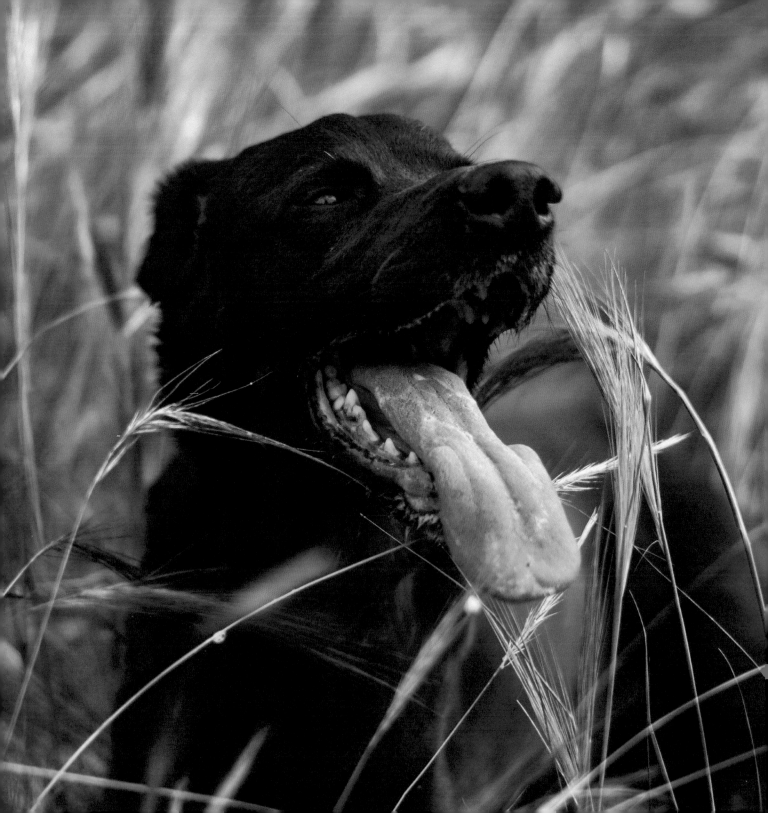

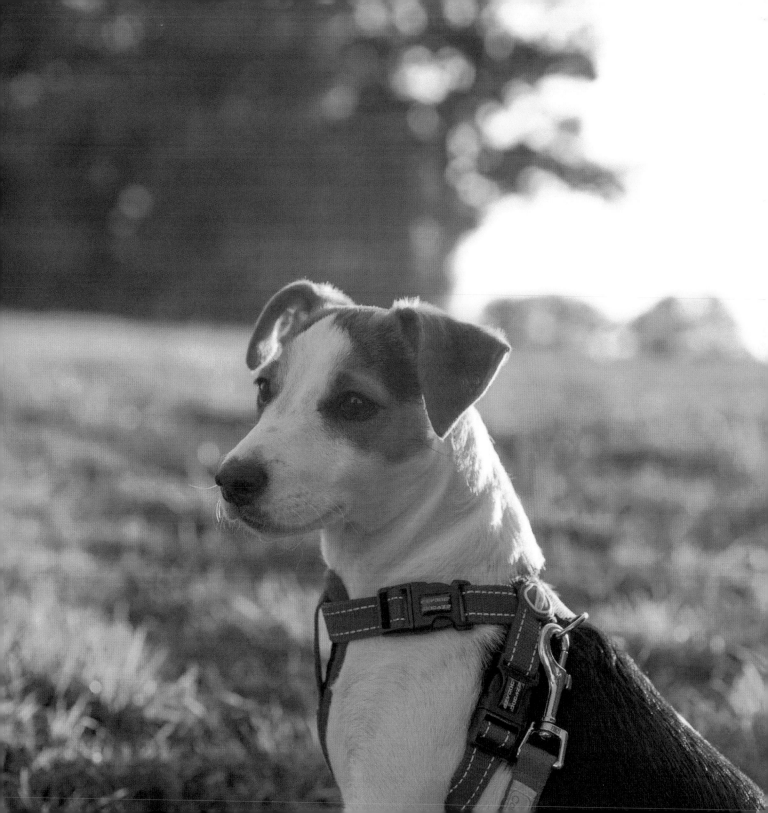

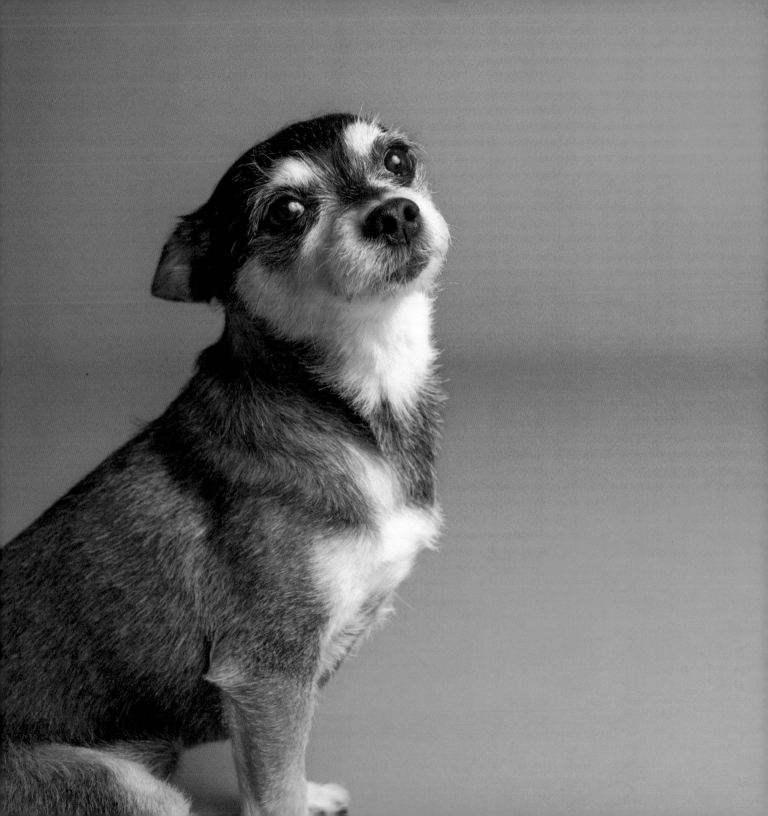

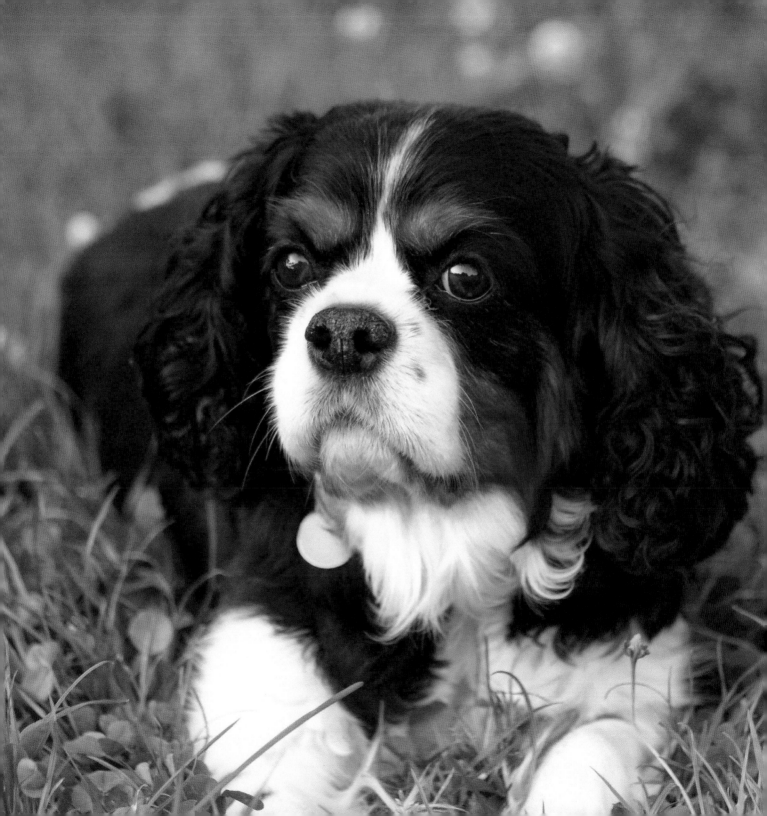

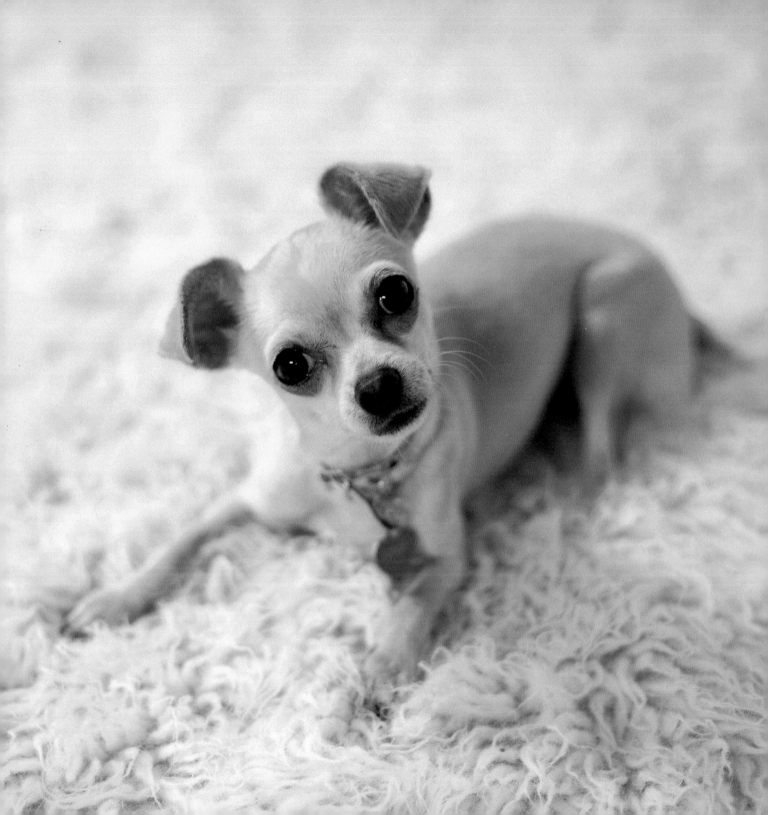

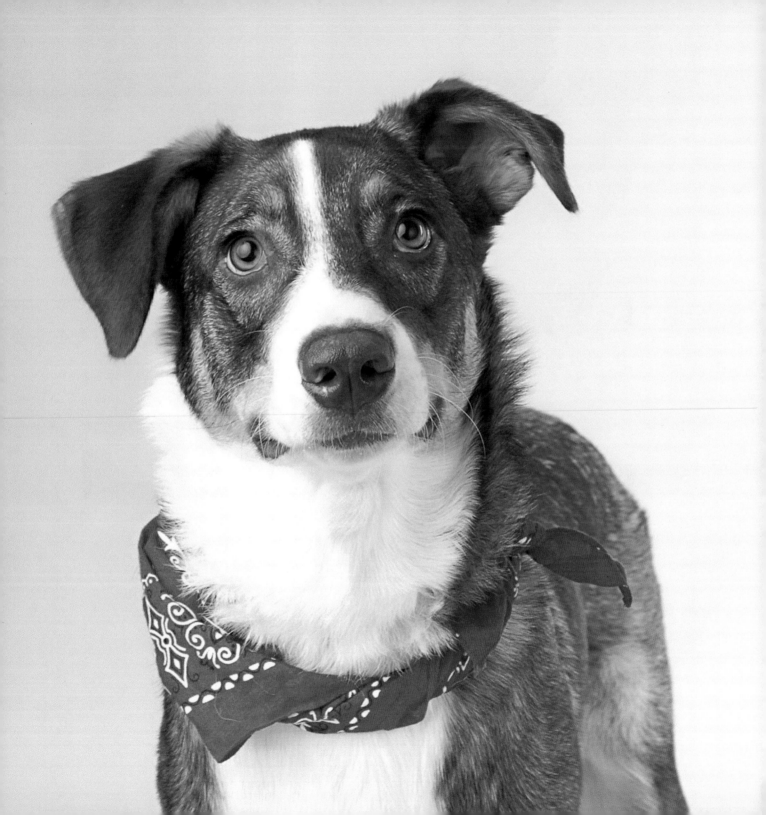